MEON

A Painter's Journey
Down the River Valley

BRYAN DUNLEAVY

MEON

Published by Magic Flute Publications 2013

ISBN 978-1-909054-09-7

Magic Flute Publications is an imprint of
Magic Flute Artworks Limited
231 Swanwick Lane
Southampton SO31 7GT

www.magicfluteartworks.com
www.magicflutepublications.co.uk

Illustrations © Bryan Dunleavy

A description of this book is available from the British Library

Contents

Preface

I started this project early in 1997 with the intention of completing later that year. In the previous year I had a successful exhibition of my paintings of the Test Valley: *The River Test From Source to Sea*. It was now the turn of the Meon Valley but a few months later more pressing demands on my time postponed its completion in that year. The project hovered in my mind but more years elapsed than perhaps should have and here I am in 2013. Circumstances this year did make it possible to put some energy into finishing the job. The passage of 16 years has led to one crucial change. The original plan was to mount an exhibition of paintings but that no longer seems to be the best approach. Instead, I have availed myself of the recent revolution in printing technology which now makes it possible to present these images in book form. This has some advantages: the book form makes the images more accessible and also changes the scope of the project. Whereas an exhibition would aim to present highly finished paintings, the book form is more elastic and can permit the inclusion of sketches and illustrations.

The original concept was to follow the course of the river from its source to the sea, a distance of only 21 miles, but a 21 miles of compelling variety of landscape and human settlement. I think I have remained true to this and I have travelled in and out of the valley, across the roads and bridges, up the downs and through the lanes to find images of interest. There have been omissions as knowledgeable readers will quickly note, but in the end it comes down to personal choice. Those parts that have caught my eye or interest have been sketched, drawn or painted, other parts have been omitted or neglected.

I have, for example, omitted Fareham, now sprawling from the valley across to Fareham Creek. This seemed to big to include and may perhaps be another project.

The lower parts of the valley are now very densely populated, part of that ribbon development that now extends along much of the south coast. Most of the land now occupied by Stubbington, Titchfield Common, Locks Heath, Whiteley and Fareham was entirely agricultural at the beginning of my life. In the lower reaches the river and its valley can still retain its attractive appearance but close to the M27, the illusion of rural life is punctured by the constant roar of traffic. By contrast the mid and upper sections of the valley retain some semblance of the tranquility of the countryside.

Even this is not immune to change. Since I started the project, shops and post offices have closed, some businesses have come and gone, some pubs have disappeared, probably for ever. Despite this there is still much to please the eye and warm the spirit in this historic valley.

Bryan Dunleavy

The Source

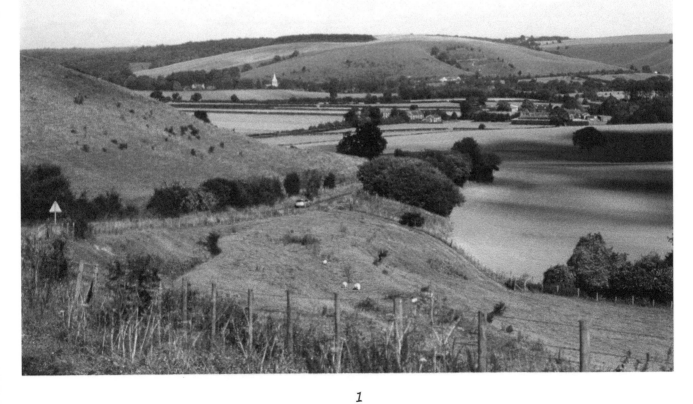

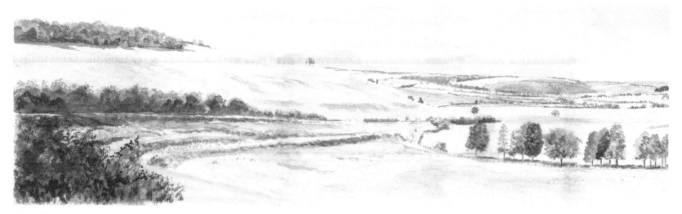

This great basisn drains the waters that eventually rise in a rather unprepossessing spring a little to the north of this viewpoint.

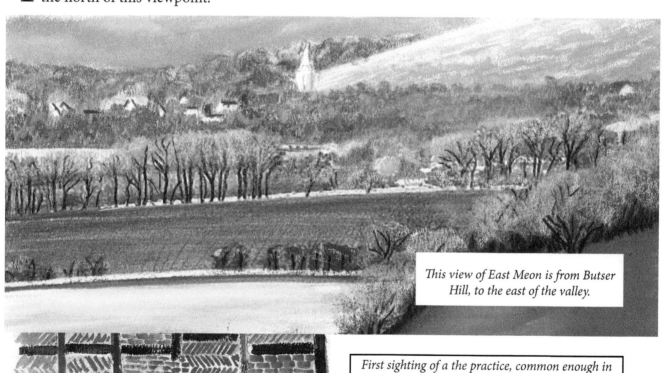

This view of East Meon is from Butser Hill, to the east of the valley.

First sighting of a the practice, common enough in the valley, of filling the space between timber frames with bricks, often arranged in a herringbone pattern

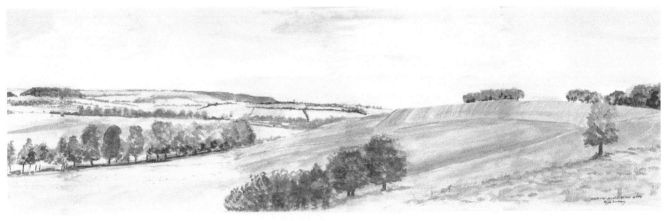

This is the view from Hyden Cross, barely 10 miles from the ribbon of coast al development that hugs the M27, an oasis of rural calm where there may be more sheep than people.

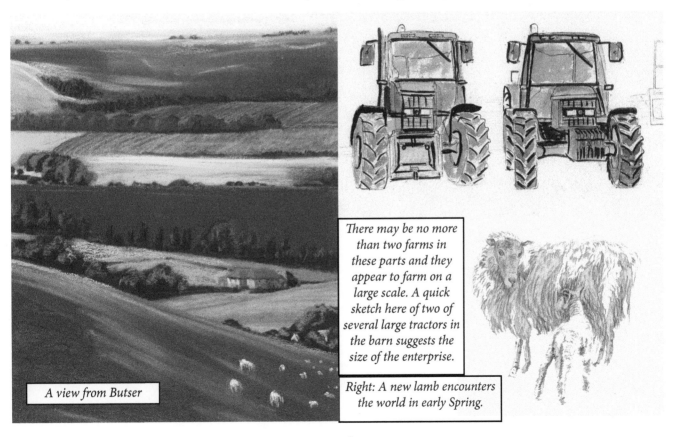

A view from Butser

There may be no more than two farms in these parts and they appear to farm on a large scale. A quick sketch here of two of several large tractors in the barn suggests the size of the enterprise.

Right: A new lamb encounters the world in early Spring.

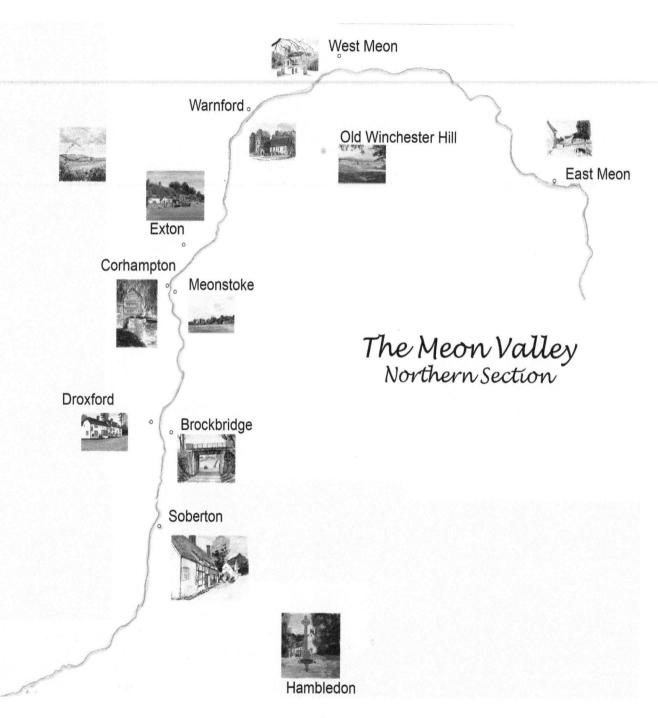

West Meon

Warnford

Old Winchester Hill

East Meon

Exton

Corhampton

Meonstoke

The Meon Valley
Northern Section

Droxford

Brockbridge

Soberton

Hambledon

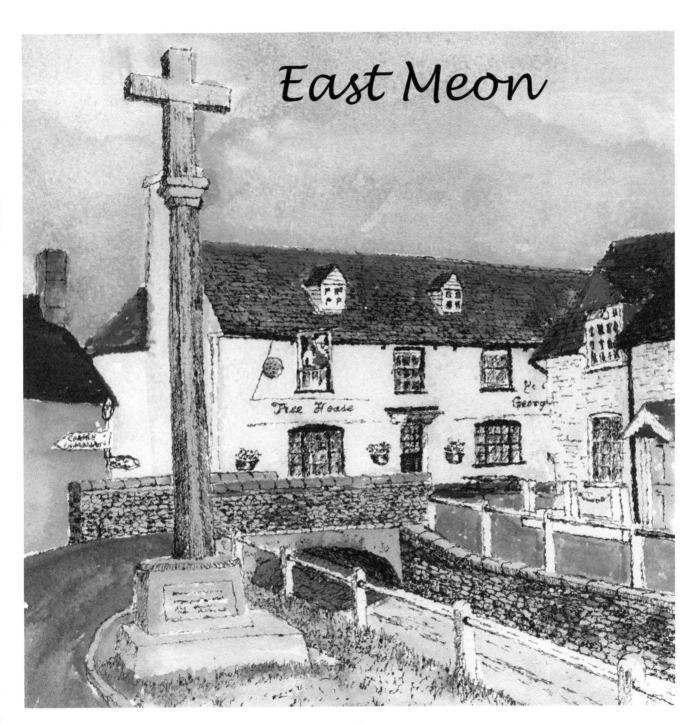

East Meon

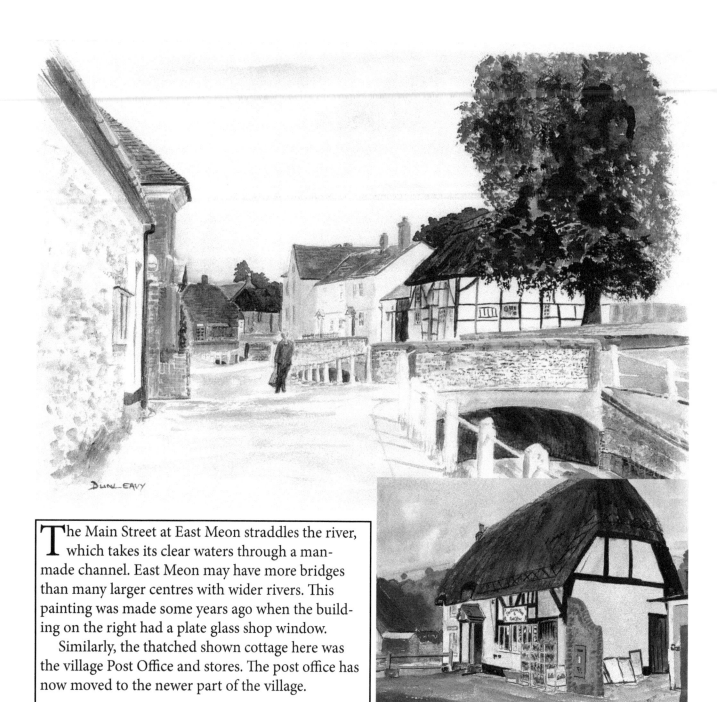

The Main Street at East Meon straddles the river, which takes its clear waters through a man-made channel. East Meon may have more bridges than many larger centres with wider rivers. This painting was made some years ago when the building on the right had a plate glass shop window.

Similarly, the thatched shown cottage here was the village Post Office and stores. The post office has now moved to the newer part of the village.

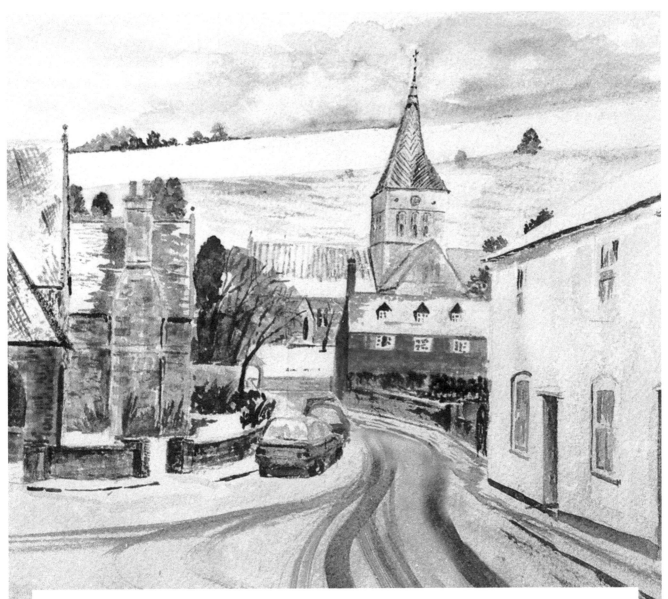

This painting was done after a February dusting of snow. Here is the old church cut into the side of the hill on the other side of the Petersfield road. At left are the alms houses.

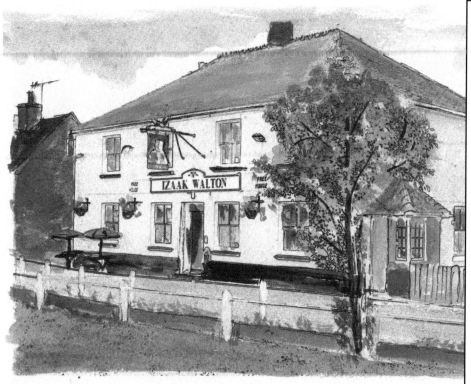

Izaak Walton was a 17th century London ironmonger who retired early to devote himself to pleasurable pursuits, such as fishing. He became famous for recording his advice in a book called *The Compleat Angler*, which subsequently became a classic. What is his connection with East Meon? Well he was certainly a good friend of George Morley, Bishop of Winchester, and he did live for a time at the Bishop's Palace at Farnham. He probably explored the Hampshire streams and the pub here is named in his memory.

The manor was also the centre for the hundred court and the old 14th century manor house is known as the Court House to this day. The walls are apparently 4 feet thick, built of stone and flint. A survey of the manor undertaken in 1647 describes an impressive building, although somewhat in need of repair, and, interestingly, mentions a hop yard. Clearly the manor was taking care of its brewing requirements. At the time of this survey the manor of East Meon extended well into Sussex.

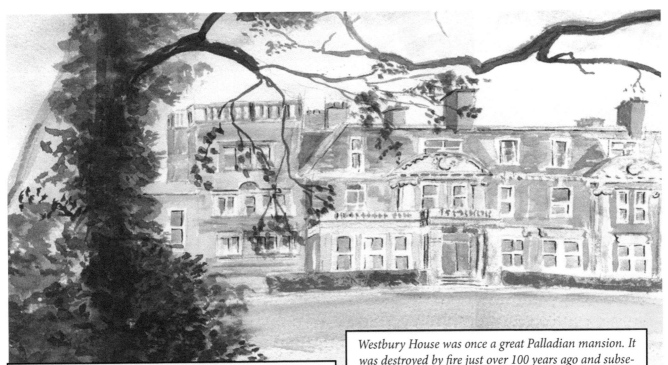

Westbury House was once a great Palladian mansion. It was destroyed by fire just over 100 years ago and subsequently rebuilt. It is now a nursing home.

From East Meon the river winds westwards to the village of West Meon. The road is narrow and winding, but the slopes of the valley provide some interesting views along the way.

On one occasion I climbed a hill on the north side of the valley for a better view and stood there watching two men with metal detectors scouring a ploughed field. When they saw me watching them they came up to me probably thinking that I was the landowner and waswondering about their activities. After a short conversation they realized that I was just a bystander but in the course of the exchange I learned that there was indeed treasure trove from earlier settlements to be found in this valley.

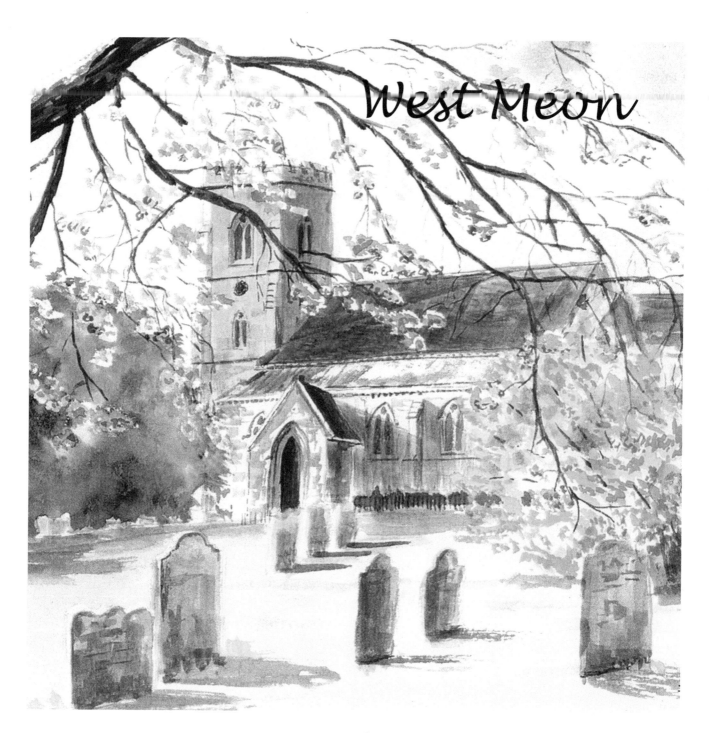

West Meon

On the preceding page, West Meon Church at May blossom time. The church was re-built by the rector at mostly his own expense at the very considerable sum of £12,000 in the mid 19th century. The architect was the then 21 year-old, but later very famous Sir Gilbert Scott.

The cross on the triangle at the centre of the village was erected at the beginning of the 20th century as a memorial to George Vining Rogers who worked in this village as a medical practitioner for over 40 years.

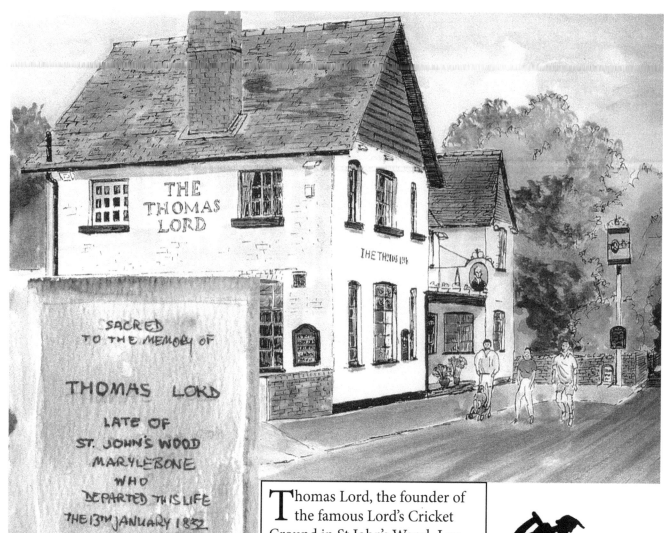

SACRED
TO THE MEMORY OF

THOMAS LORD

LATE OF
ST. JOHN'S WOOD
MARYLEBONE
WHO
DEPARTED THIS LIFE
THE 13TH JANUARY 1832
AGED 76 YEARS
FOUNDER OF
LORD'S
CRICKET GROUND
1787

Thomas Lord, the founder of the famous Lord's Cricket Ground in St John's Wood, London, retired to West Meon and was buried in the churchyard. On the bi-centenary of his death the MCC installed a new gravestone. The village pub is named in his memory.

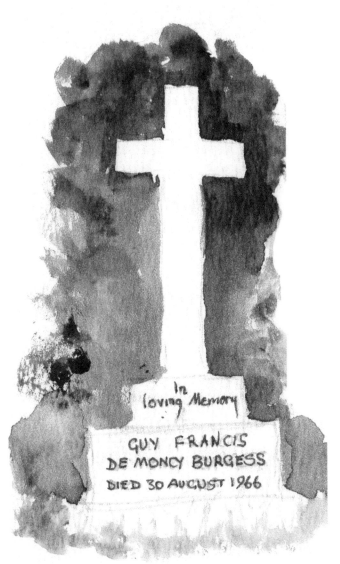

Still in the graveyard, here is the final resting place of the infamous spy Guy Burgess who was privately interred by his family after his death. Burgess, along with his fellow Cambridge University conspirators, was at the heart of the English establishment, which made his betrayal all the more astonishing. All the reasons for taking Burgess into the intelligence services – right public school, right university – therefore "one of us", proved ironically to be the very ones which enabled them to betray their country and the lives of those directly affected with a clear conscience. I remember the fuss at the time and haven't paid much attention to it since, but I suspect that these men were as much motivated by contempt for the changes they saw in our western democracy, where the old order was giving way to the new, and coupled this with idealistic ignorance of the development of the new system of government then being trialed in the Soviet Union.

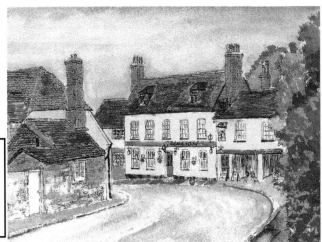

Above: Sketch of the gravestone erected to Guy Burgess.
Left: The Red Lion pub at West Meon, as it was a few years ago before being restored to a private house.

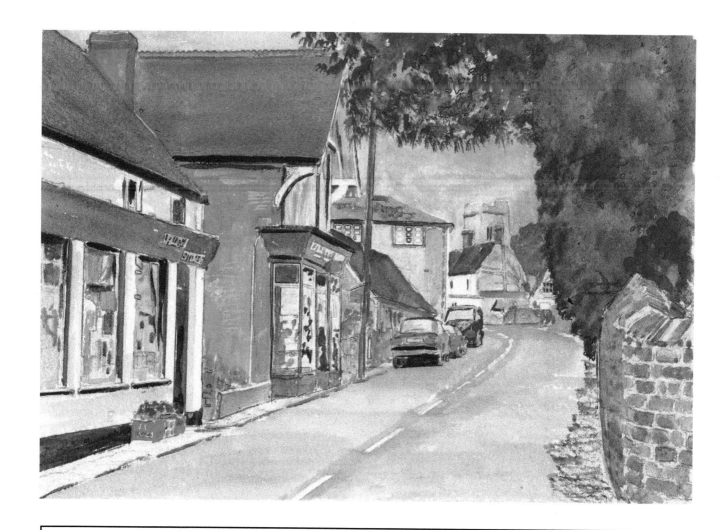

At West Meon the river makes the second of its right angle bends before it begins its main course south west to the Solent. West Meon is at a crossroad on the A32 and is of necessity busier than its sleepy East Meon neighbour. It managed, when I painted these watercolours, to sustain a butchers shop, a post office and a general store, and two pubs. The Post Office, as an independent entity has now gone and The Red Lion has returned to a private residence. Times change quickly, even in small villages.Nevertheless, with its random collection of houses and cottages built at different periods in the village's long history it retains a great deal of charm.

Meon Valley Railway

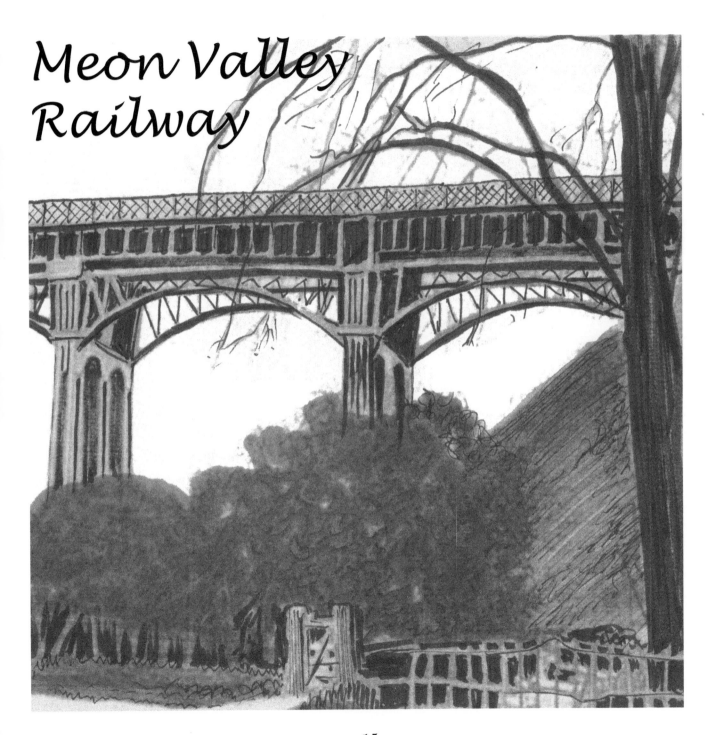

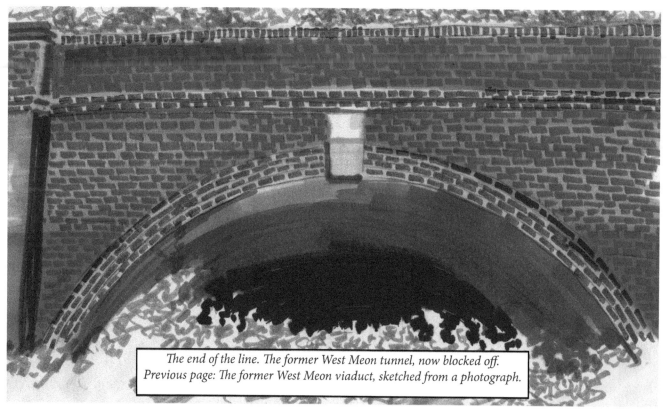

The end of the line. The former West Meon tunnel, now blocked off.
Previous page: The former West Meon viaduct, sketched from a photograph.

The short-lived railway, the remnants of which end abruptly at West Meon, was created to link Gosport and Alton. The railway was a late addition to Britain's railway network, some 60 years after the first railways and long after the railway mania of the 1860s. It was a considered and well-planned enterprise by the established L & SWR who wished to establish a direct link between Alton and Gosport. The Isle of Wight was becoming a popular tourist destination and Lee on the Solent was also a growing resort. In addition Gosport and Fareham were expanding. The valley was not a great engineering challenge of but there were two significant obstacles - the high land near Privett and crossing the east-west section of the Meon Valley. Privett was negotiated through a very long tunnel of 1000 yards and a second, shorter tunnel on the other side of the A272 to West Meon. The line then had to cross the deep but narrow valley over a 64 ft high viaduct to reach West Meon station.

The line was completed for opening in 1903 and for a number of years boosted the agricultural economy of the valley as product could now be quickly dispatched to market. 59 years later the line could not survive the cuts by the

government of the day and it closed in 1962.

Parts survive. The tunnels have now been blocked off. The impressive viaduct over the Meon at West Meon has gone, mainly because it was an iron structure and had a high scrap value. The foundation of the pillars remain. Some parts of the old line, beginning here at West Meon and extending to Knowle can be used as a bridle way and several of the road and river bridges are still in use. The former station at Droxford is now a private house and the Railway Hotel at Droxford

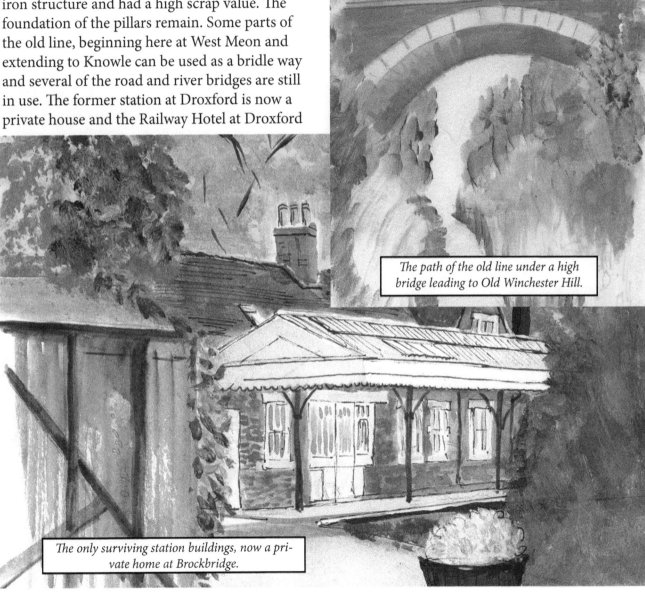

The path of the old line under a high bridge leading to Old Winchester Hill.

The only surviving station buildings, now a private home at Brockbridge.

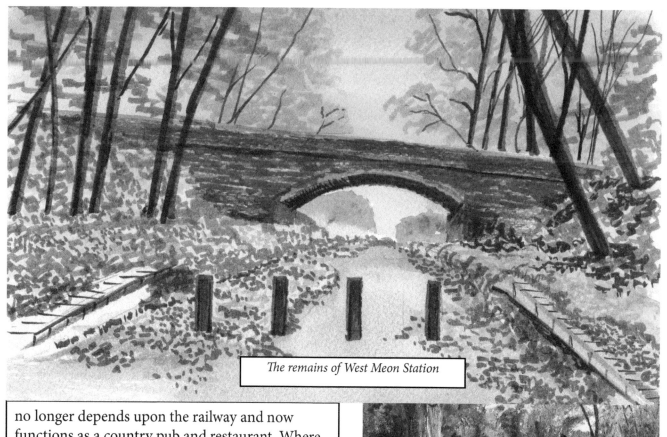

The remains of West Meon Station

no longer depends upon the railway and now functions as a country pub and restaurant. Where there are bridle paths, especially near Wickham the walks are well worth it as the higher vantage point of the embankment offers some excellent views of the river. Some of my paintings have been done from these views.

West Meon's station was dismantled in the 1970s but the line remains as does the high bridge which carries Station Road over it. Station Road is now a country lane continues to Old Winchester Hill and the only nod to a former railway is the brick parapets that briefly interrupt this tree-lined lane.

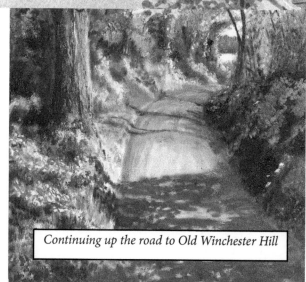

Continuing up the road to Old Winchester Hill

18

Above the Valley

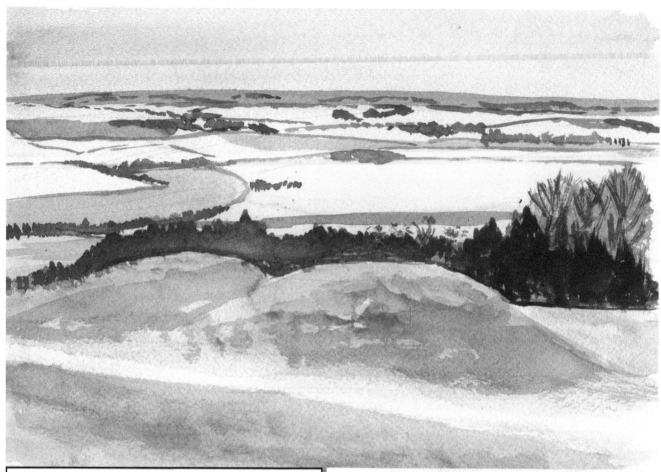

On the previous page Beacon Hill on one side of the valley.

Above a view of the two burial mounds, round barrows, dating from pre-historic settlements on Old Winchester Hill. This commanding point is the site of an iron age fort which was settled 2,500 years ago.

On the right some windswept tress that brave the elements at over 650 feet above sea level.

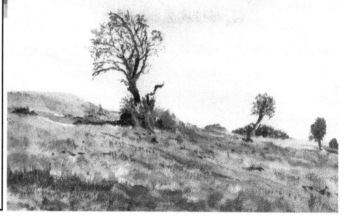

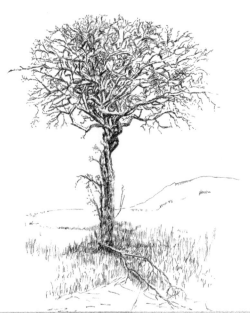

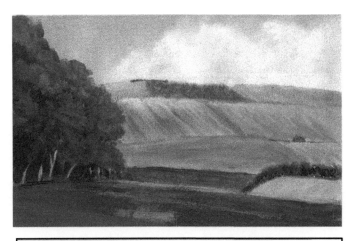

To the left a weathered tree on Old Winchester Hill.
Above, a view of some of the high farmland.
Below, a quick sketch of a sunset from Old Winchester Hill.
Next two pages: Another view from Old Winchester Hill
Page 24: Harvesting above Combe Valley.

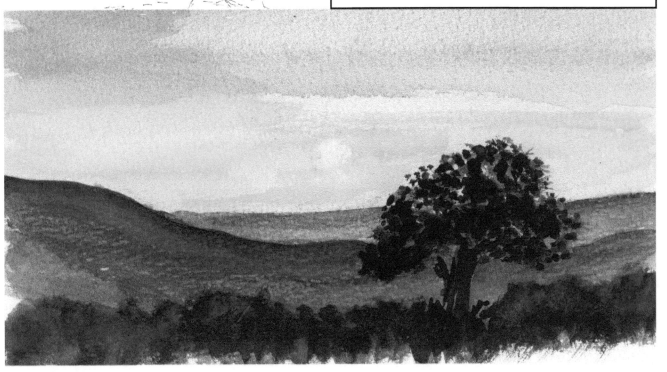

21

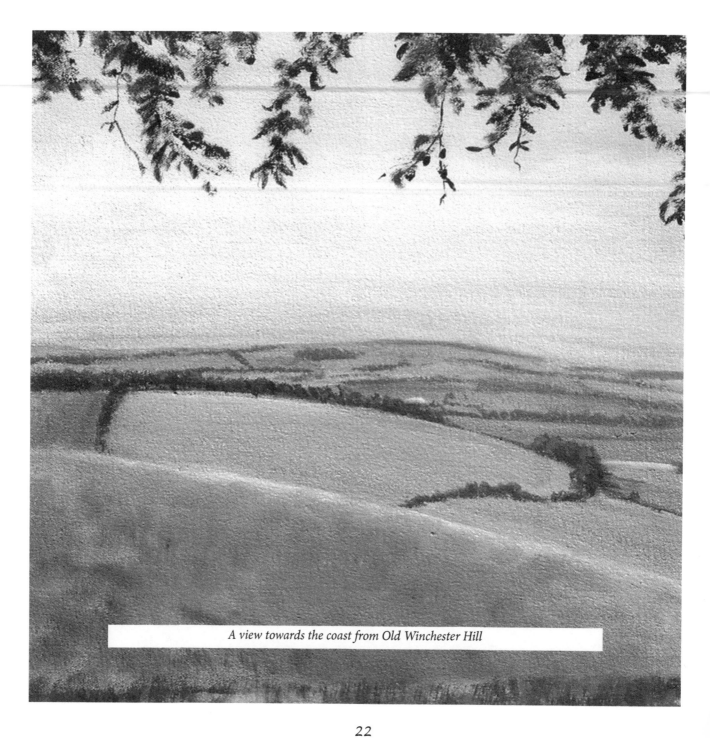

A view towards the coast from Old Winchester Hill

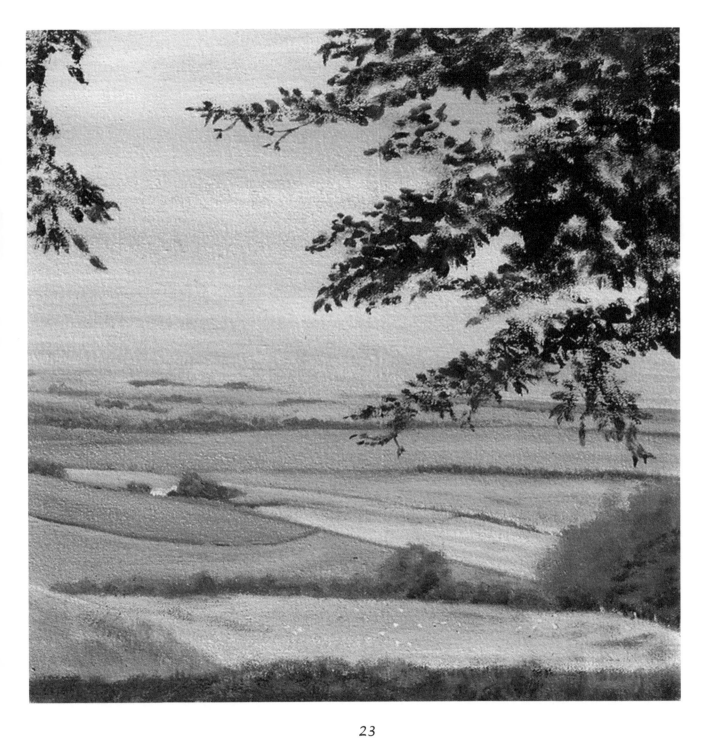

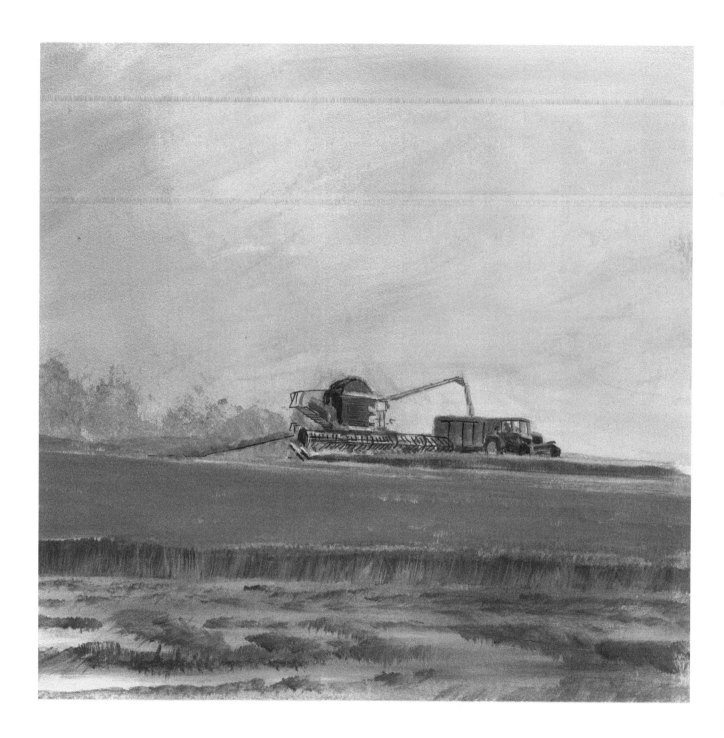

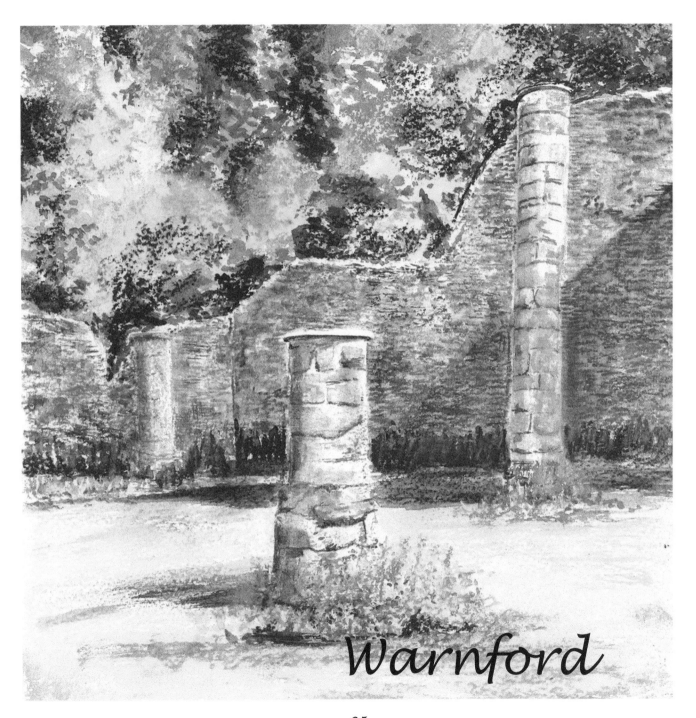

Warnford

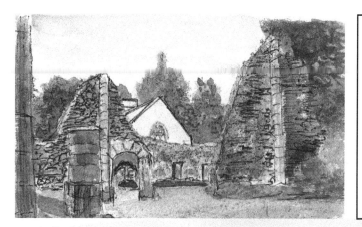

Here and on the previous page, the ruins of the "St. John House", built by the dominant family in the 13th century. The church is next to it.

There was also a great house nearby, built in the 17th century and much enlarged in the following 200 years. It was dismantled in the 1950s. Some sections of the ornamental gardens remain, but these are private.

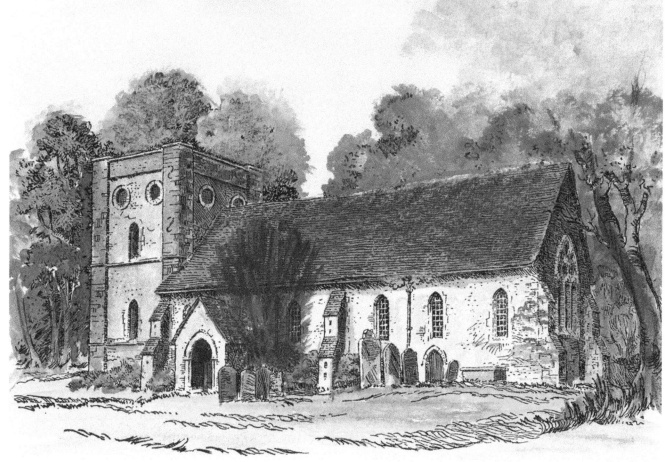

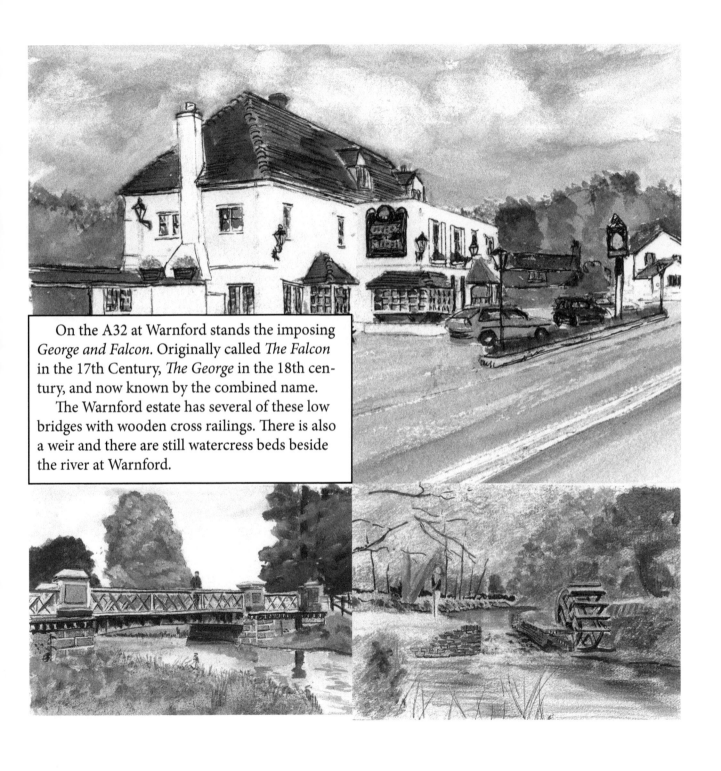

On the A32 at Warnford stands the imposing *George and Falcon*. Originally called *The Falcon* in the 17th Century, *The George* in the 18th century, and now known by the combined name.

The Warnford estate has several of these low bridges with wooden cross railings. There is also a weir and there are still watercress beds beside the river at Warnford.

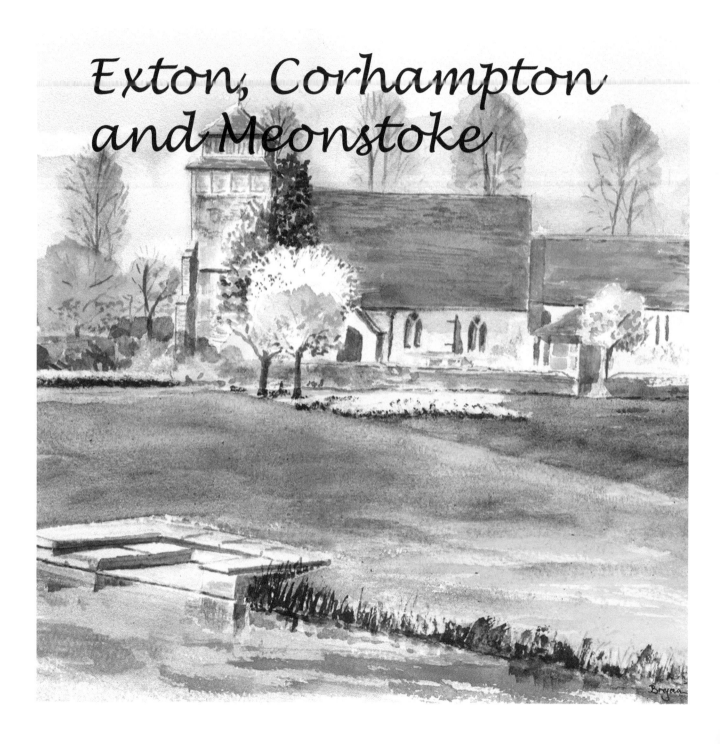

Exton, Corhampton and Meonstoke

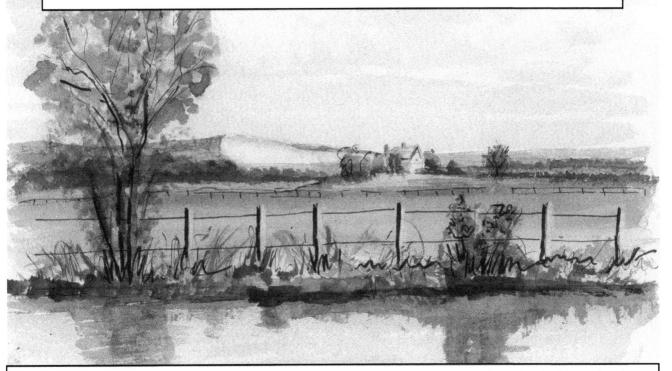

Exton, Corhampton and Meonstoke make a curious cluster of villages, each within half a mile of each other. They derive from Saxon land divisions. Meonstoke extends over 2000 acres to the south and east of the river. Corhampton covers an equivalent amount of land to the west of the Meon and Exton spreads to the north west. In each case settlements were made, in the corners of these estates probably due to the presence of a mill on the river and a valley road. So Corhampton's church is no more than 100 yards from Meonstoke's, separated only by the stream. Exton and Meonstoke were ecclesiastical holdings so there was no reason to build a great house in either place. Corhampton's great house was built at Preshaw, some miles away from the village settlement.

The river opens up to meadow land in these parts and the villages of Exton and Corhampton snuggle up to the edges of the steep downs. Each of these villages has charm. The A32 bypasses Exton at Sheep Dip Bridge and proceeds straight to Corhampton village where one can continue to Droxford or climb the hill over to Bishops Waltham. Corhampton's 11th century church, one of the oldest in the country, is largely hidden by a vast yew tree, itself several hundred years old.

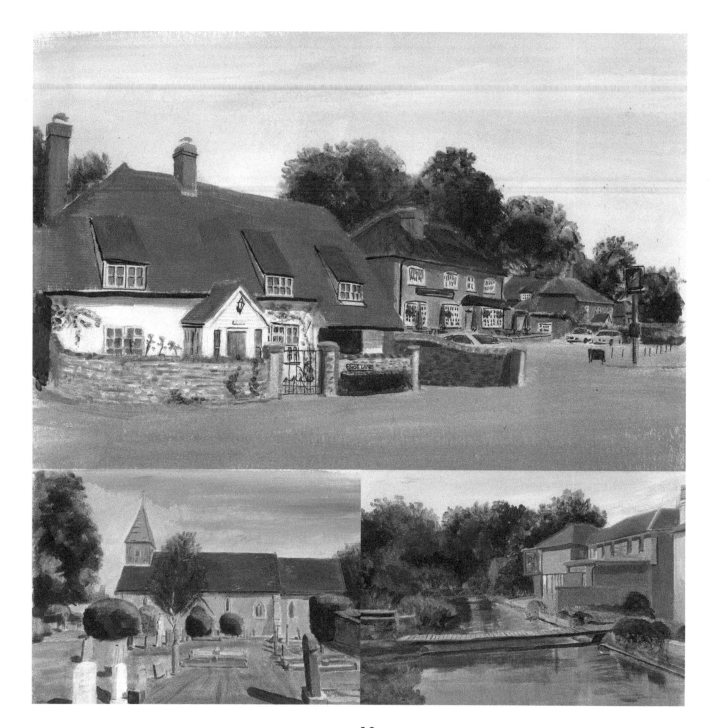

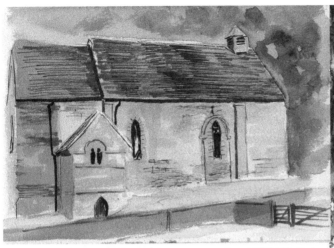

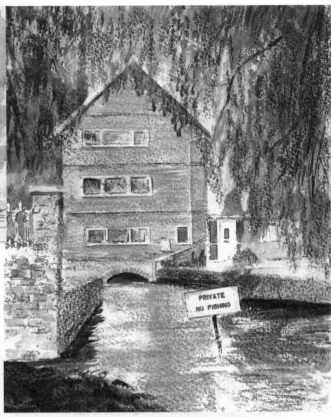

On the previous page: Views of Exton village
Above: Corhampton's Saxon Church
Right: Converted Mill at Corhampton
Below: A View towards Meonstoke

PRIVATE
NO FISHING

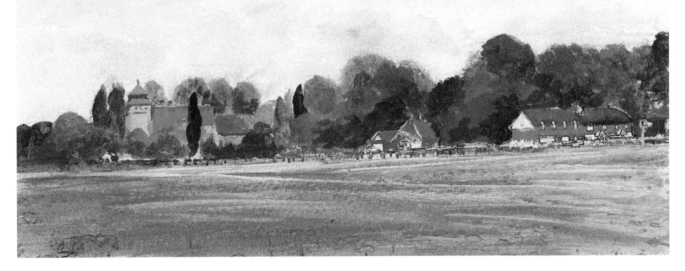

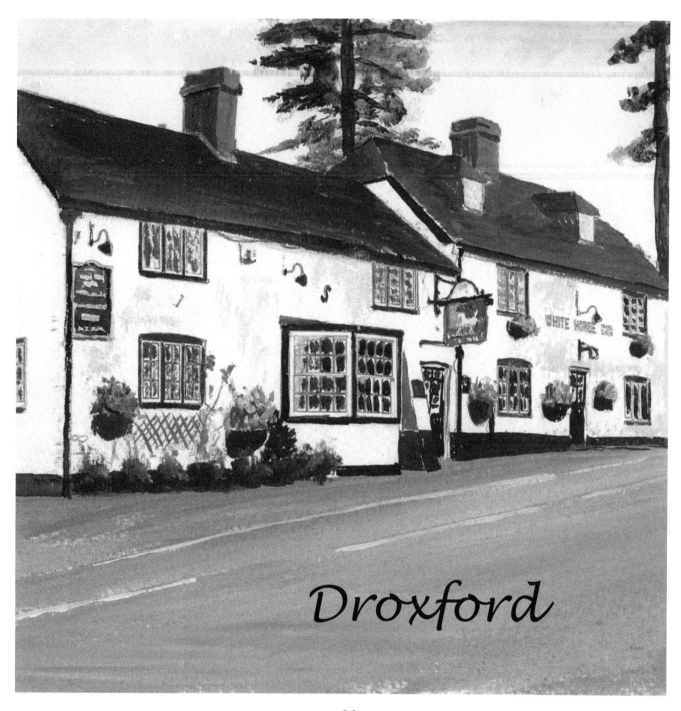

Droxford

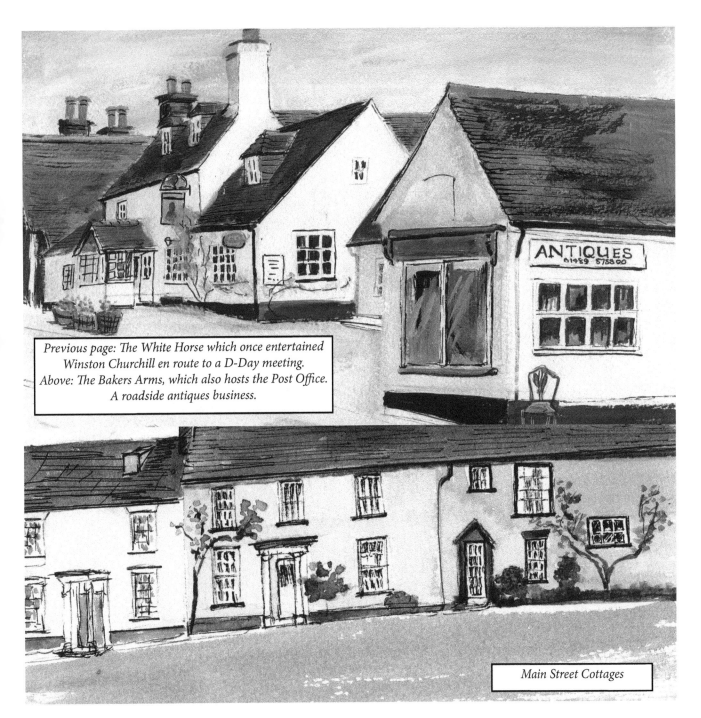

Previous page: The White Horse which once entertained
Winston Churchill en route to a D-Day meeting.
Above: The Bakers Arms, which also hosts the Post Office.
A roadside antiques business.

Main Street Cottages

Drokensford (Droxford) was once a huge tract of land that at one time included parts of Botley and the modern parishes of Swanmore and Shedfield. It was in the hands of the Bishop of Winchester before and after the Conquest. This was no obstacle to the rise of prominent families. There is one John of Drokensford in the 13th century who became Keeper of the wardrobe to Edward I and was later appointed Bishop of Bath and Wells and eventually Lord Chncellor of England.

After the 16th century monastic dissolution the manor was granted to the Earl of Wiltshire, then restored in the reign of Queen Mary and remained in the bishop's possession until the 17th century civil war when it was sold. At the restoration of 1660 it was once again restored to the bishopric, so in reality, with a few short

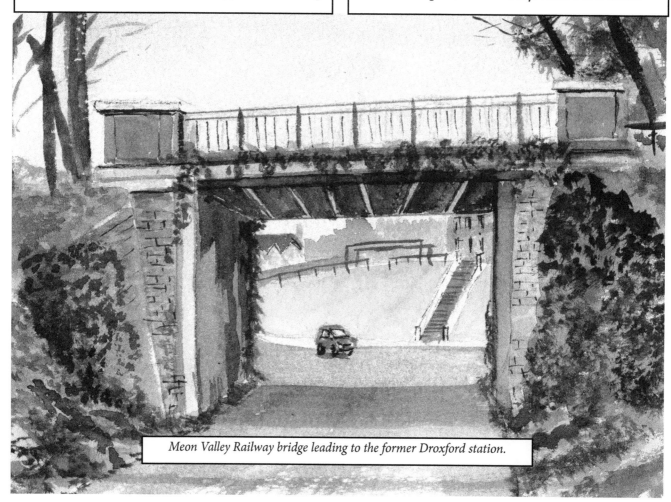

Meon Valley Railway bridge leading to the former Droxford station.

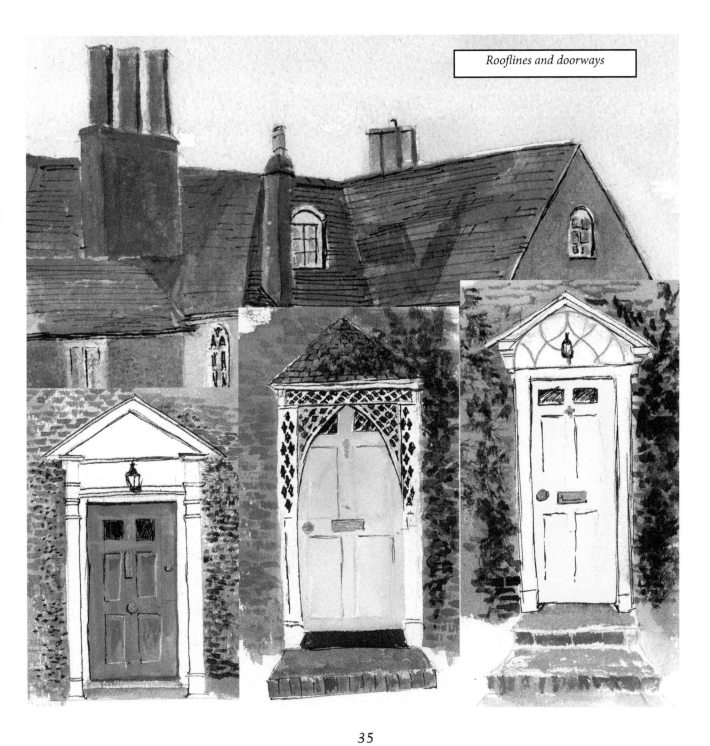

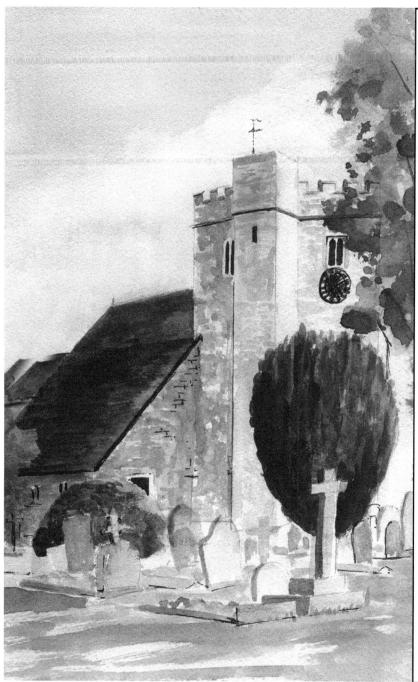

interruptions, Droxford has been in ecclesiastical hands for 1000 years. This has probably coloured its history, leaving no great personal estate in these parts.

The village stretches along a ridge on the west side of the valley. The church, in a dip closer to the river, might properly be regarded as the centre of this elongated village. There are a few back streets on the west side, one of which includes a large 19th century police station. At one time Droxford was a court centre for this part of Hampshire.

Izaak Walton also makes a connection with Droxford. As noted earlier in the section on East Meon, he was a great friend of the Bishop of Winchester, and this probably had no small part in securing the rectorhip at Droxford for his son-in-law. One presumes that when visiting here, he found time to pursue his passion for fishing along the banks of the river.

Swanmore and Shedfield were for centuries part of the Droxford parish but 19th century growth led to the creation of two separate parishes in the middle of the 19th century. Shedfield has remained small but Swanmore, at the intersection of many cross country roads has grown

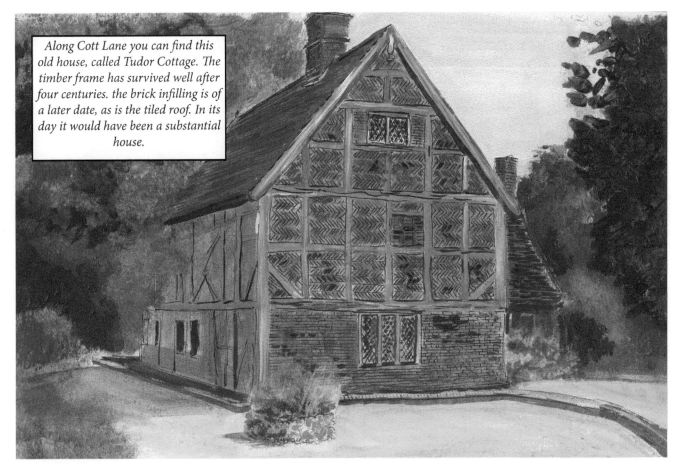

Along Cott Lane you can find this old house, called Tudor Cottage. The timber frame has survived well after four centuries. the brick infilling is of a later date, as is the tiled roof. In its day it would have been a substantial house.

greatly, particularly in the last part of the 20th century and it now seems overcrowded.

Swanmore has the distinction of being the birth place of the celebrated Canadian writer Stephen Leacock. He was born there in 1869 but in 1875 emigrated with his parents to Canada. The Leacocks were a well-established Hampshire family but Stephens father, Walter, was not a successful man. He first went to South Africa with his young wife to establish a farm there. The business failed and he returned to Hampshire to live in Swanmore for a few years. They emigrated once more, this time to set up a farm in Ontario. He appears to have been unsuccessful here too but was able to keep the family going with remittances from England. By contrast Stephen's career was stellar. He became a professor at the University of Toronto and once he turned his hand to writing became a household name. The Stephen Leacock Museum in Ontario is known as Swanmore Hall.

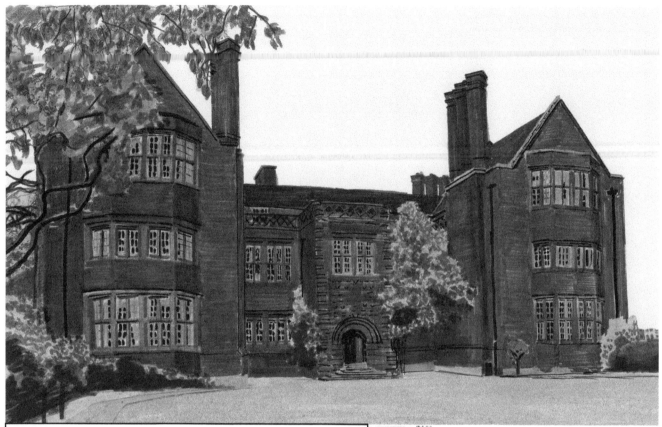

New Place was designed by Sir Edwin Lutyens and built in 1906 for Mrs Anna Sophia Franklin, then a widow. Her husband was in the tobacco business, then a lucrative trade. They lived at Shedfield Lodge and were largely responsible for funding the church building and the Reading Room. New Place was exactly that, designed by Lutyens at the height of his creative powers and is a splendid example of the arts and crafts style. The interior rooms are spacious and wood panelled. Although a large and spacious house it was quite modest compared to Shedfield Lodge which was occupied by her eldest son and family.

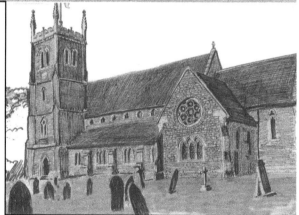

Top: New Place
Above: Shedfield Church

Soberton and Hambledon

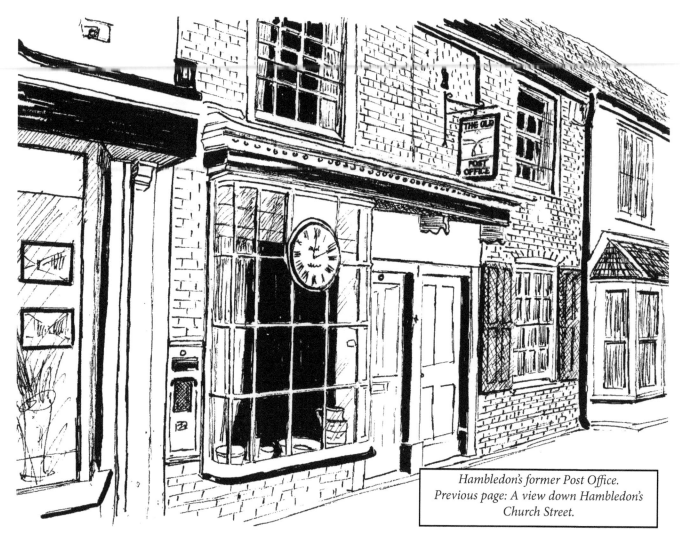

Hambledon's former Post Office.
Previous page: A view down Hambledon's
Church Street.

The eastern bank of the river is bordered by the large parish of Soberton. The Wayfarer's walk crosses to river at Droxford and goes east up to Hambledon.

This village is at the centre of a crossroads in a valley and is a very old settlement. There are the remains of a Roman Villa a short distance away.

The church has been much added to over the centuries but within it is an almost complete 11th century church that pre-dates the Conquest. The building was much enlarged in the 13th century and a tower was added in the 18th century, but because the older parts were generally incorporated a visit to the church is of great interest. There was apparently a fire in 1788 which obviously destroyed the timber framing, but the church was

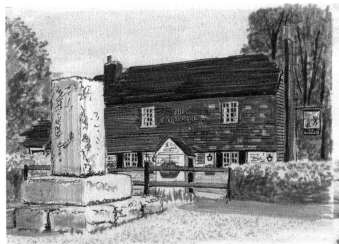

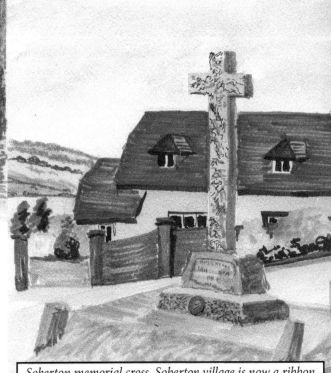

Soberton memorial cross. Soberton village is now a ribbon development of several miles dow to Soberton Heath. The cross is about half way down, possibly in the middle of this now extended village.

restored in the 19th century.

The High Street, which leads up to the church is a wide street that was probably used as a market place. There are buildings on either side that date to the 17th century although many have been modernised over the centuries. The bumped-out frontages suggest that many were shops at one time, although it now appears to be an entirely residential street.

There is an old Manor House in the centre of the village, parts of which date from the 13th century. The house at the crossroads, now known as George House, was a former 18th century coaching inn.

It is said that the rules of modern organised cricket had their origins on a remote hill above Hambledon and some 400 feet above sea level. The Hambledon Club was a social club of Hampshire gentry who set about organising cricket matches with some success in the later half of the 18th century. These men were not necessarily players, but they enjoyed the occasion which af-

forded opportunities for betting. The club probably recruited useful athletes from some distance to put together a team that could beat their opponents, there were at least 50 occasions where the club played an England XI and triumphed in a majority of those encounters.

The Hambledon Club did not invent cricket but its success and prominence gave it a leading role in codifying the rules of the game. The length of the pitch and the third stump in the wicket for example, originated with the Hambledon Club.

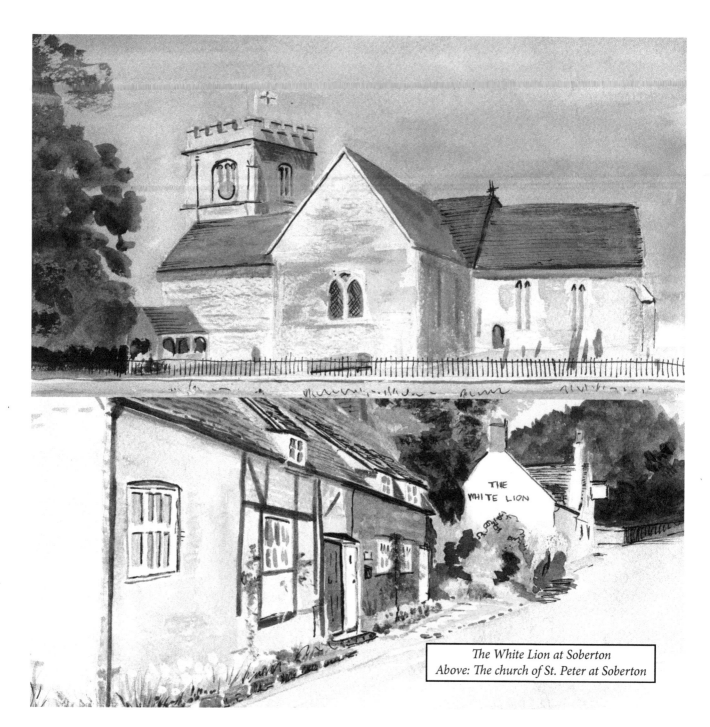

The White Lion at Soberton
Above: The church of St. Peter at Soberton

42

At the close of the century the centre of gravity shifted to London and the Marylebone Cricket Club took over responsibility for the game, a position it holds today. Hambledon lost its important place and became another village cricket club. The game is still played here, a little lower down on a flatter ground.

The Bat and Ball Inn was of probably no small importance to the development of the game and there was likely many a discussion surrounding pots of ale.

Soberton, on the east bank of the river stretches for miles. Some claim it as the longest village in England. The church, and possibly the centre of this village is perched on top of a hill. It boasts a prominent tower which is now almost 500 years old.. Parts of the church date to the 13th century but it appears to have been subject to considerable rebuilding and addition over its medieval history. A stone coffin, dating to the period of Roman occupation was discovered here, suggesting that the site has a very old history indeed. The coffin is on display outside the southern wall of the church. Close by is the White Lion Inn, some houses and a school built in the 19th century. The former school is now a private house.

Such a huge territory (almost 6,000 acres) meant that even 1000 years ago Soberton was divided into three or more manors. These manor houses survive in part as farm houses, or have disappeared. One of them, Flexland in the south, was owned by the Bishop of Winchester, and at the time of the dissolution was scooped up by that great acquisitor of ecclesiastical properties in Hampshire, Sir Thomas Wriothesley, later the 1st Earl of Southampton.

The river from the railway

43

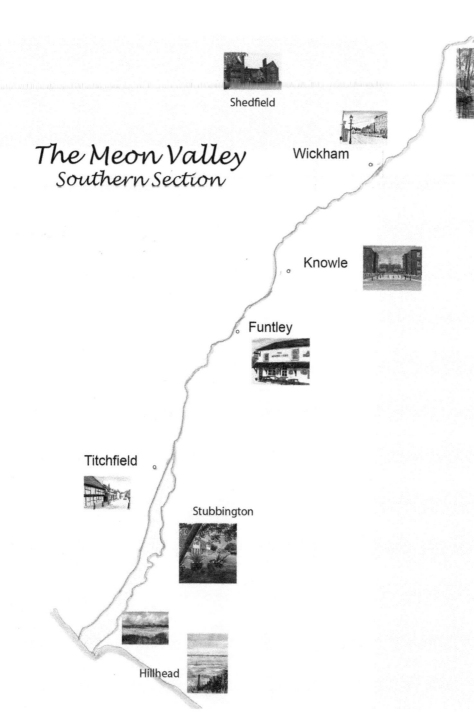

The Meon Valley
Southern Section

Shedfield

Wickham

Knowle

Funtley

Titchfield

Stubbington

Hillhead

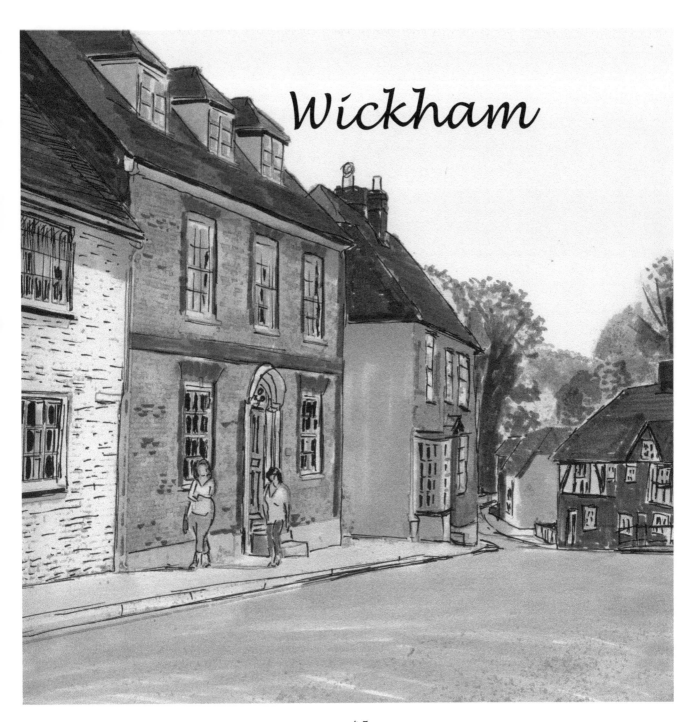

Wickham

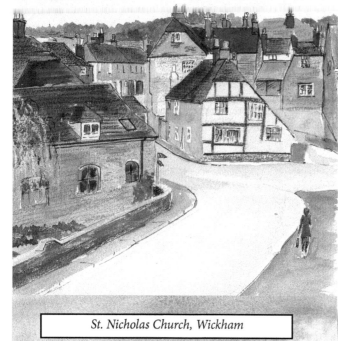

A view from the railway bridge

Somewhere in the parish of Wickham the most famous man from these parts, William of Wickham was born, around 1320. His father was a freeman, which placed him a step above the general run of peasantry, but even so it can be said that William grew up in modest circumstance. However this bright young man rose to become Chancellor of England and Bishop of Winchester. When he died at the end of a long life he was one of the richest men in England. He is remembered mostly for his school foundations - Winchester College and New College in Oxford.

Wickham has enjoyed some prosperity over the years and is still a thriving town today. The large square is invariably full and shops are rarely vacant Apart from supermarket shopping the town is probably central for most people in the valley.

St. Nicholas Church, Wickham

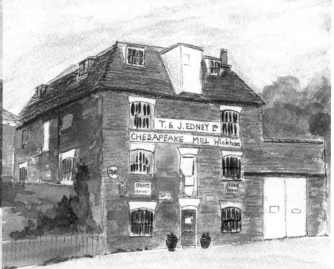

Chesapeake Mill, now an antiques centre

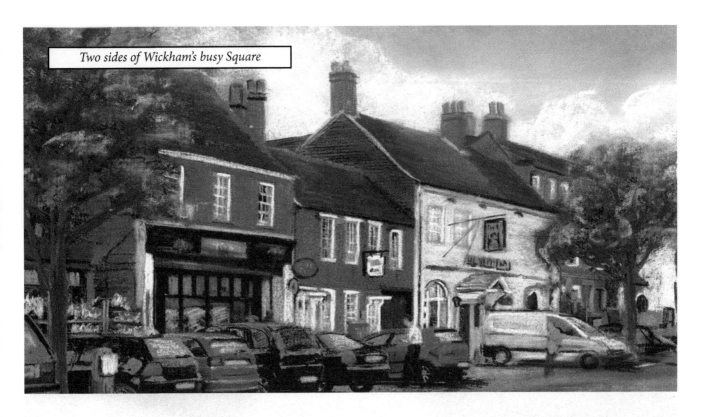

Two sides of Wickham's busy Square

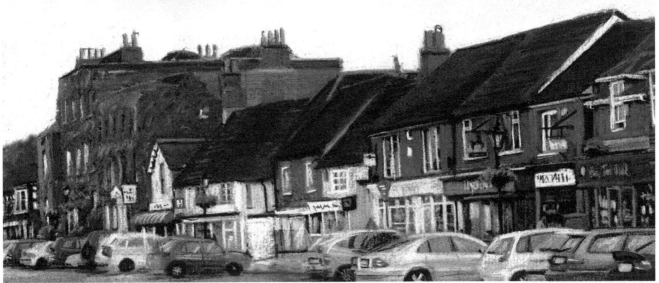

47

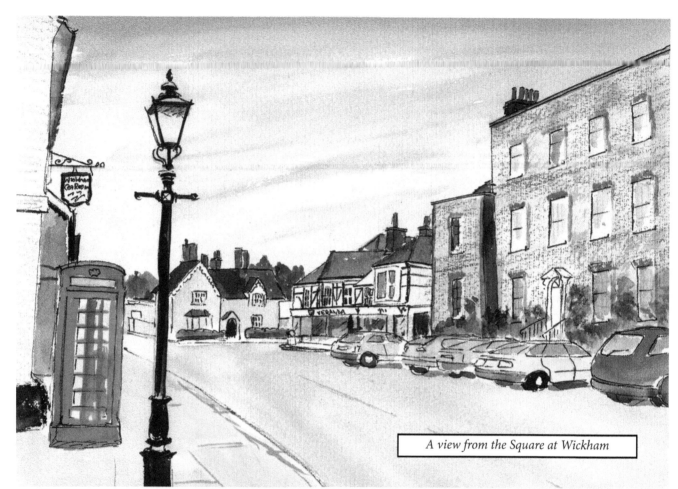

A view from the Square at Wickham

The large square, bordered by Georgian and 19th century buildings is the central feature of the town. The A32 by-passes the town to the east. The church was separated from the town by the railway line and is a little adrift on the east side of the A32. Two bridges survive for the defunct railway line we visited earlier.

When you enter Wickham you can find former coaching inns on both sides of the square. There are earlier buildings, on Bridge Street for example, and later ones, but overwhelmingly on the square the buildings owe their origin to the 18th century.

Wickham has an interesting association with the war between Britain and the United States. The USS Chesapeake was captured by the Royal Navy in a battle in Massachusetts bay in 1812. It was brought to Portsmouth and the timbers sold in 1819. They were used to construct the mill at Wickham which was henceforth known as the Chesapeake Mill.

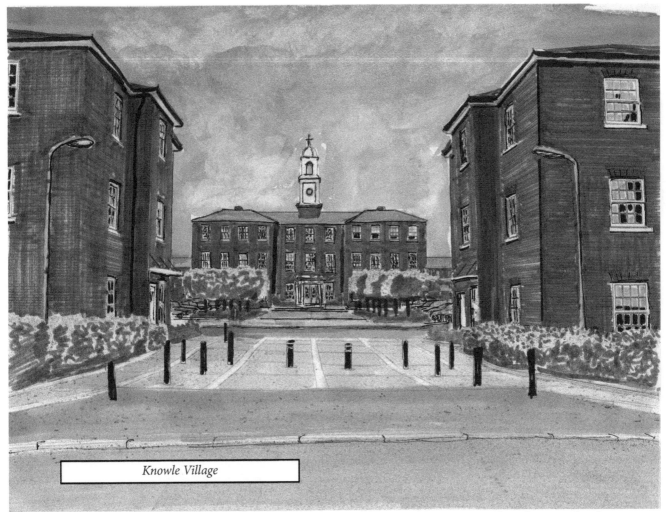

Knowle Village

Just south of Wickham is the former Knowle Hospital built in the middle of the 19th century as a lunatic asylum. The complex of buildings at one time housed over 2,000 patients. Society's ability to cope with mental illness has changed drmatically in recent years and eventually institutions like this became redundant. About a decade ago the buildings were redeveloped as apartments and further building was undertaken on the farm to create Knowle Vilage. Here is a current view.

Just off the Titchfield Road you can find a rather poorly kept lane called *Iron Mill Lane*. An Iron Mill? Yes, it is surprising for these parts but at one time there was a very famous iron mill beside the river here.

There was no iron ore in these parts nor was

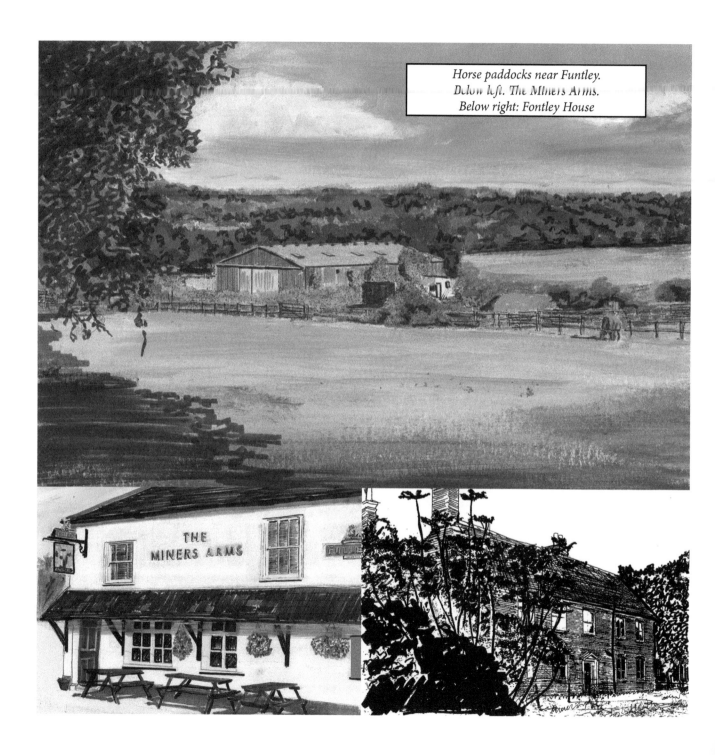

Horse paddocks near Funtley.
Below left: The Miners Arms.
Below right: Fontley House

there a close supply of coal, but there was a river to provide water power and a ready market at Portsmouth for iron products. Henry Cort, the instigator and founder of the mill was already in business in supplying iron to the navy. In about 1779 he determined that he could produce iron hoops required to band barrels for on board storage at about 1/3rd lower cost than the Navy were then paying. With encouragement from the Navy he built a mill at Funtley which then re-worked iron into hoops..

The enterprise was not altogether a financial success but Cort's real claim to fame in this industry is his invention of a puddling process which produced a purer quality of iron than hitherto had been obtained. For this Henry Cort is a noted figure in the development of iron production.

Cort died in 1800 but the mill continued at this rural location until 1852, but it could not survive in the 19th century, where larger iron works with ready access to iron ore and coal could use Cort's technique with greater economies of scale.

Today the river is an overgrown stream and an unused mill race with no evidence that it was once an 18th century industrial base. Fontley House was once inhabited by Samuel Jellicoe, one of Cort's partners.

The Miner's Ars at Funtley village is another curiosity. It dates to the time of the construction of the railway when a number of Welsh miners were brought in to labour on the building of the line. The new public house was close to the workers' camp and was therefore named after its regular clientele.

Wickham Vinyard

An old milestone at Shedfield

BPS WALTHAM
3
MILES
GOSPORT
10
MILES

Titchfield

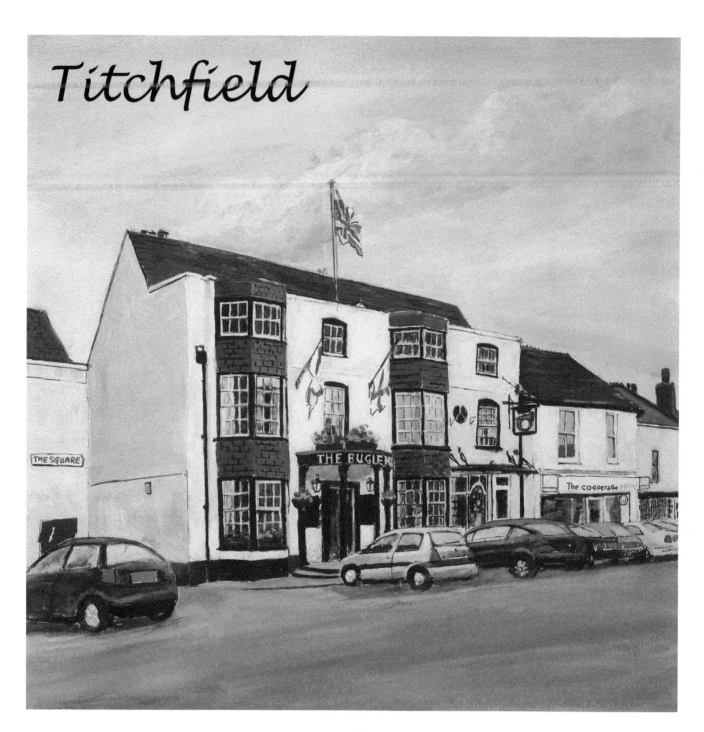

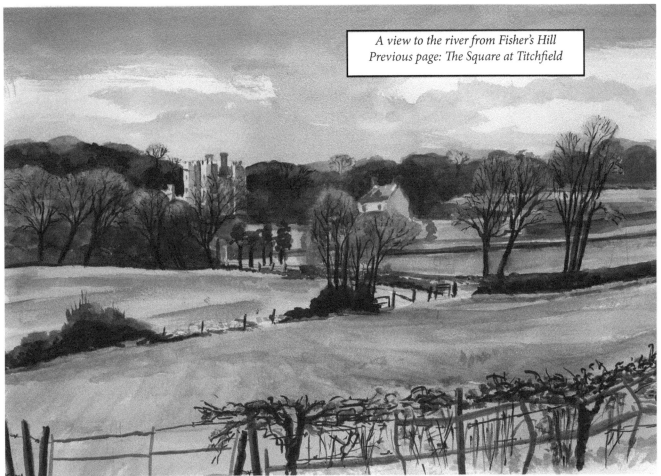

A view to the river from Fisher's Hill
Previous page: The Square at Titchfield

Titchfield is the last village before the sea. Two miles inland, it was for a long time the port village for the area. Although it seems hard to imagine today, boats could readily come upstream from the Solent and some of the older houses facing the river have evident merchant associations. A canal was also dug in the 17th century although its genesis and purpose is somewhat obscure.

Titchfield is a crowded and attractive village now surrounded by busy by-pass roads. Houses are an architectural mix from the 17th century onwards which adds to its interesting visual appearance.

The village was always important and at one time absorbed most of the land between the Meon and the Hamble. In1232 the powerful Peter des Roches, Bishop of Winchester founded a monastrey here and the Premonstratensium canons prospered here for several centuries. The house was important enough to host the wedding of

53

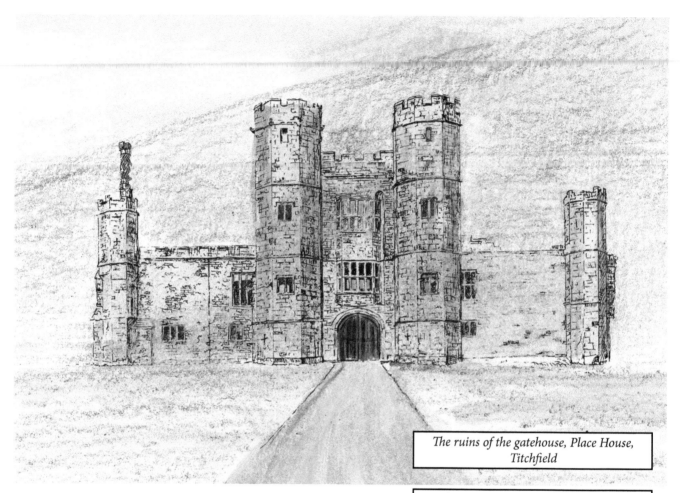

The ruins of the gatehouse, Place House, Titchfield

A selection of medieval tiles from the abbey

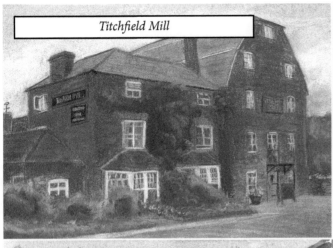

Titchfield Mill

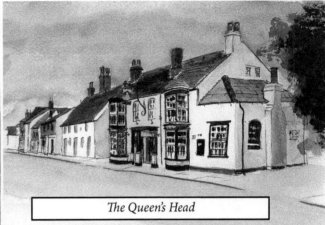

The Queen's Head

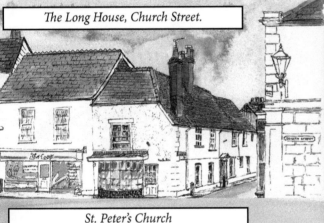

The Long House, Church Street.

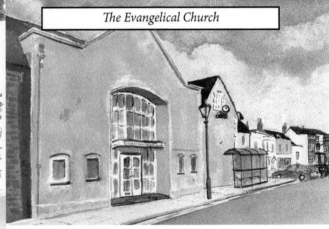

The Evangelical Church

St. Peter's Church

Margaret of Anjou to the hapless Henry VI on April 23rd. 1445 and the stone bridge crossing the river to the abbey (although the present structure does not date back that far) is still known locally as the Anjou bridge. In its first centuries the abbey prospered moderately and apparently created an impressive library, but in the years leading up to the dissolution all of its assets were stripped and when Sir Thomas Wiothesley acquired the house for £1000 it was a depleted asset.

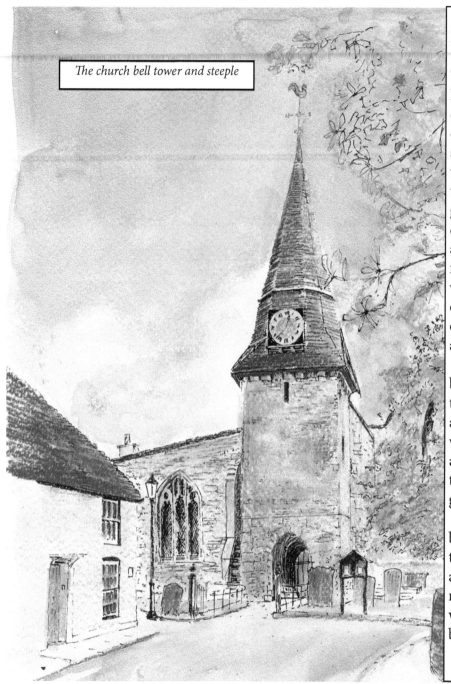

The church bell tower and steeple

He then set about emulating his contemporaries and converted the abbey into a splendid Tudor mansion which became his principal country seat. At the end of Henry VIII's reign he was created Earl of Southampton and Titchfield gained in importance. All that survives today of this building is the impressive gatehouse. The house itself was dismantled in the 18th century and much of the stone was used for new building projects. Today visitors can inspect the ruin of the gatehouse and find the outline of the cloisters and the abbey church.

A little further to the north, beside the road, is a 15th century barn and opposite the abbey a half timbered building which some claim to have been a school where Shaespeare once taught, A little further south is a great barn, a tithe barn.

The village is now cut off by the A27. The large mill on the left has been converted to a restaurant. Mill Lane has a number of riverside buildings which were once commercial buildings.

The square opens up to a

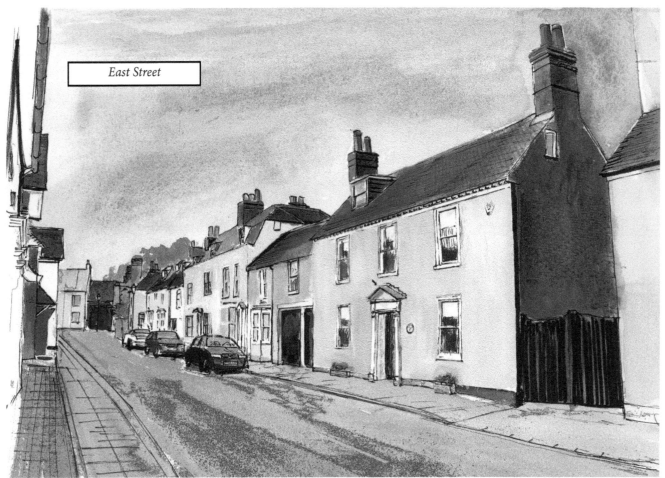

East Street

collection of shops that once met every need of the village. The car and supermarkets have transformed that and these former shops have been converted to residential use. Some survive as convenience stores and personal service outlets. There are still two pubs in the Square, both with 19th century frontages. *The Queen's Head* has two rounded bay windows jutting on to the pavement. *The Bugle* has a false front as do several other buildings. In the case of *The Bugle* the two story

building has been given false windows at the top to create the illusion of a third floor.

The Church is an old foundation which benefited from the Wriothesly influence in the 16th century. The Wriothesley tomb in a side chapel is a magnificent and expensive monument, erected on the death of the second earl.

South Street, which retains a number of half-timbered buildings presents an attractive appearance.

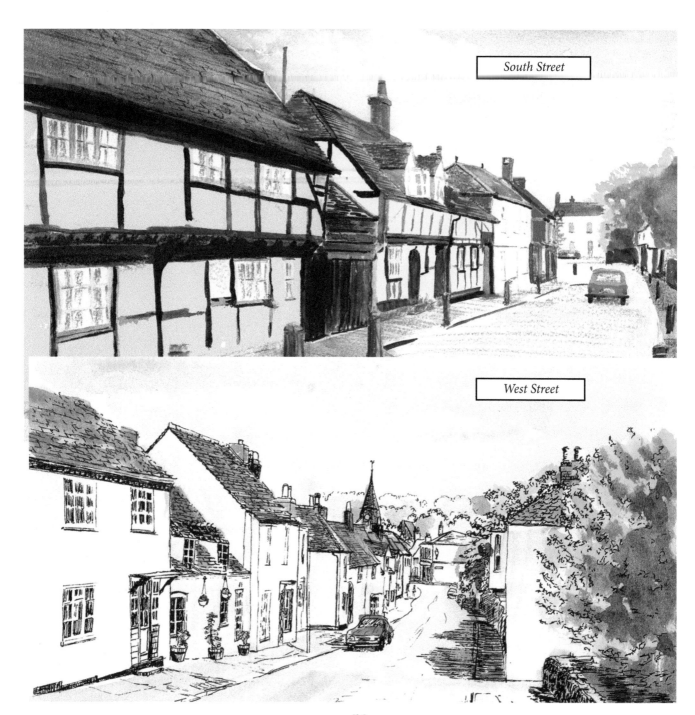

South Street

West Street

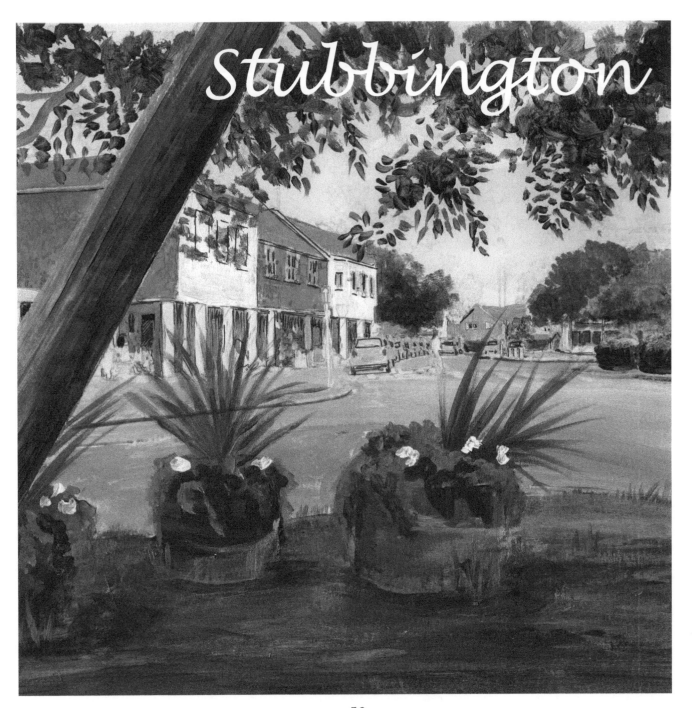

Stubbington

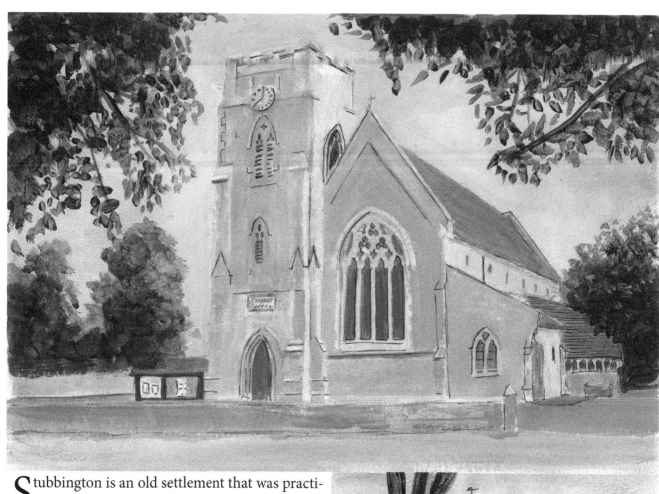

Stubbington is an old settlement that was practically uninhabited until the 20th century - a few cottages, farms and the old Crofton Church, sketched here on the right. The large late Victorian church of Holy Rood stands just off the Green which is a busy shopping and communal centre. Stubbington is now a spawling community that extends towards Fareham and merges with Hillhead on the Solent coast.

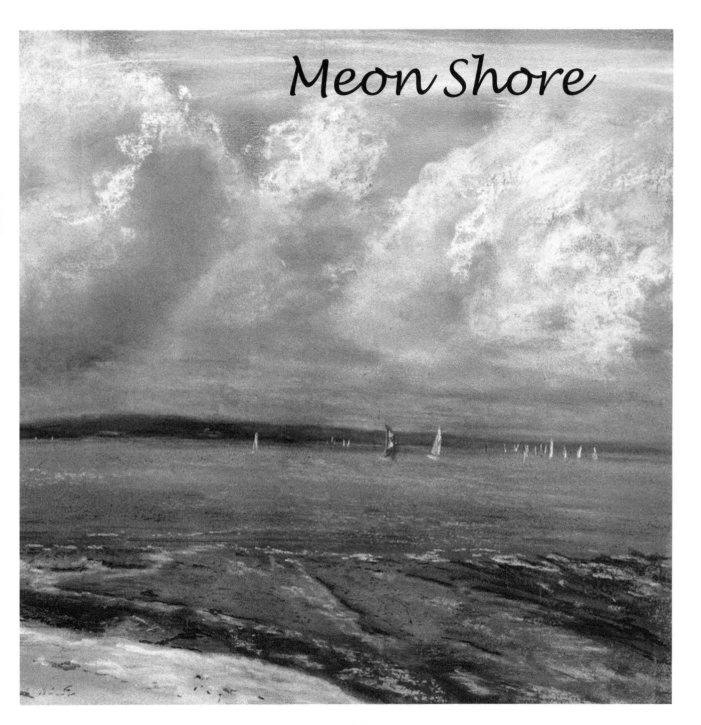

Meon Shore

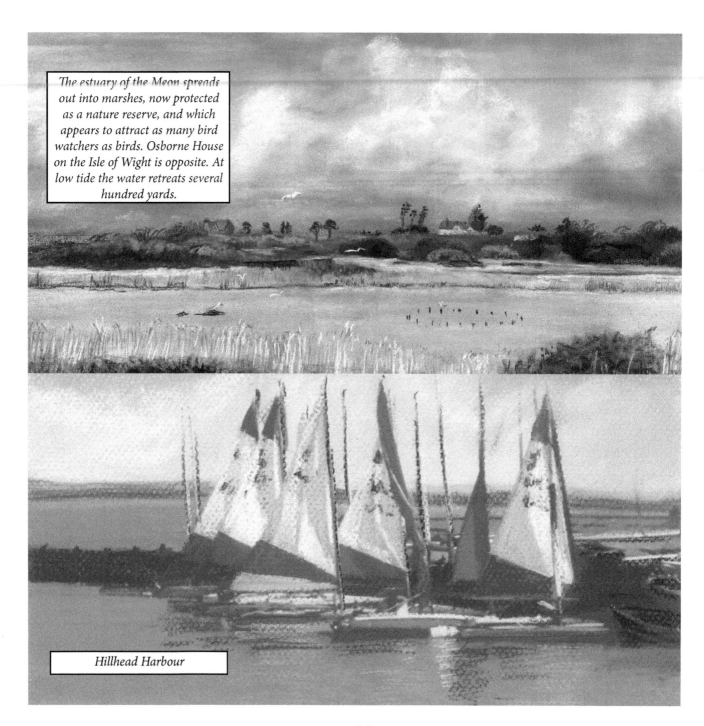

The estuary of the Meon spreads out into marshes, now protected as a nature reserve, and which appears to attract as many bird watchers as birds. Osborne House on the Isle of Wight is opposite. At low tide the water retreats several hundred yards.

Hillhead Harbour

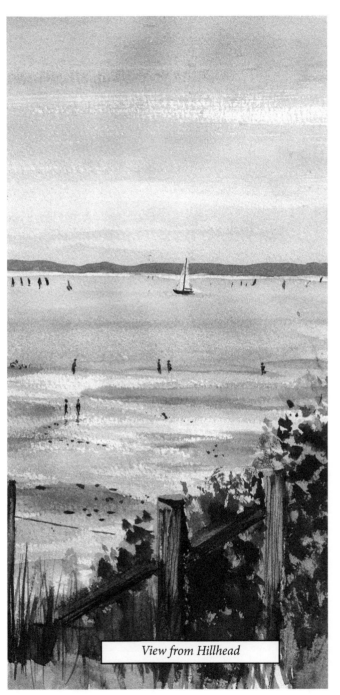

View from Hillhead

The road from Stubbington eventually leads to Hillhead, a high point on the Solent shore opposite Osborne House on the Isle of Wight. At sea level, between Hillhead and the cliffs of Chilling the Meon estuary spreads out into marshes. The land has now been annexed as a bird sanctuary.

The shore can also be approached from Titchfield down past the ancient Posbrooke Farm and across some level fields to the coast. The somewhat obscure Titchfield Canal cuts a straight path on one side of the estuary and now ends in a sluice gate. The main course of the river meanders from Titchfield to the sea in a plain that is prone to flooding. You can understand the point of the canal, although its history and usage is not well documented.

Hillhead harbour, a compact shelter, has been built at one of the estuary channels. It hosts a number of small pleasure craft.

The coast road is protected by a sea wall which, as can be seen in this painting on page 65, gets buffeted by waves when the wind is up.

The shore of course, with its beaches, beach huts, sailing craft and opportunities for wind surfing, is a place of leisure.

The river's total journey to this point has been only 21 miles. It seems like a longer journey. There are many footpaths, bridle ways up an down and across the valley that are worth exploring. I have not detailed any of this here. My purpose has been to offer some visual flavour of the life of the valley. rather than to present a guide.

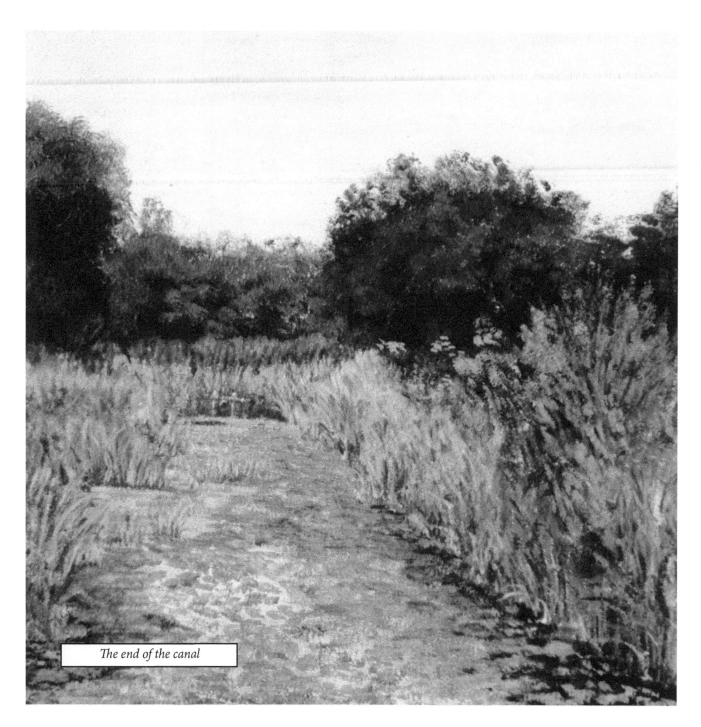

The end of the canal

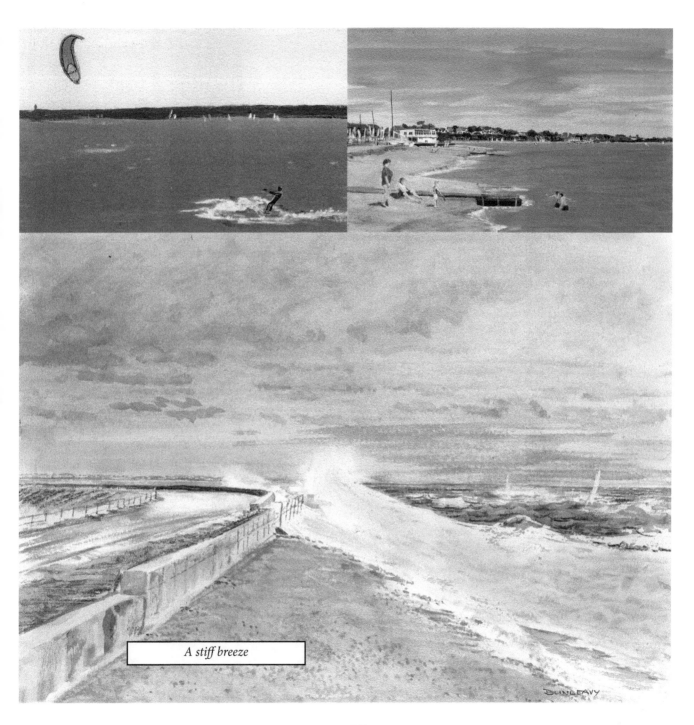

A stiff breeze

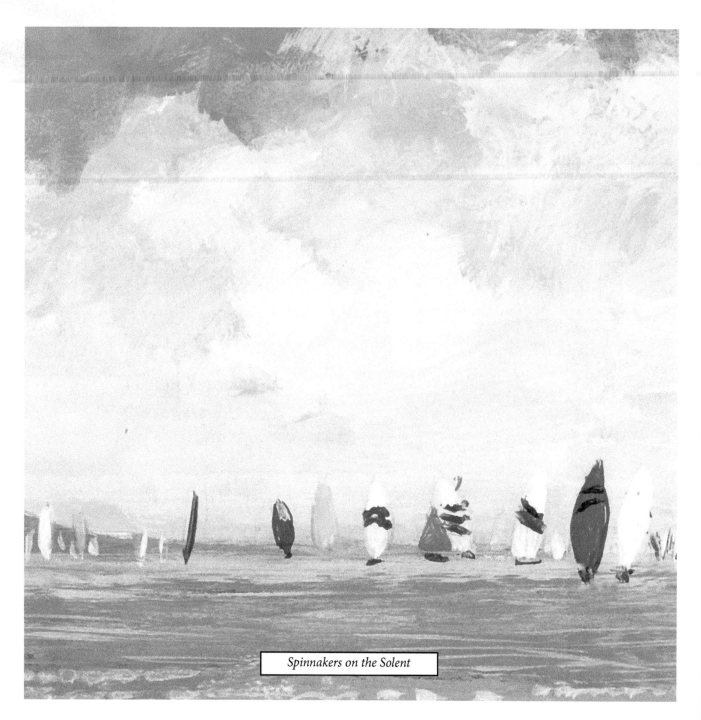

Spinnakers on the Solent

THE END

Lightning Source UK Ltd.
Milton Keynes UK
UKHW051018080722
405563UK00005B/62

9 781909 054097